What's My Style?

I love creating elaborate patterns packed with detail so I can do lots of intricate coloring. I try to use as many colors as possible. Then, I layer on lots of fun details. Here are some more examples of my work.

With my love of detail and coloring, I can easily fill up entire pages of journals like these!

Tips and Techniques

WHERE TO START

You might find putting color on a fresh page stressful. It's ok! Here are a few tricks I use to get the ink flowing.

Do you like warm colors?

How about cool colors?

Maybe you like warm and cool colors together!

Start with an easy decision. If a design has leaves, without a doubt, that's where I start. No matter how wacky and colorful everything else gets, I always color the leaves in my illustrations green. I have no reason for it, it's just how it is! Try to find something in the design to help ground you by making an easy color decision: leaves are green, the sky is blue, etc.

Get inspired. Take a good look at everything in the illustration. You chose to color it for a reason. One little piece that you love will jump out and say, "Color me! Use red, please!" Or maybe it will say blue, or pink, or green. Just relax—it will let you know.

Follow your instincts. What colors do you love? Are you a big fan of purple? Or maybe yellow is your favorite. If you love it, use it!

Just go for it. Close your eyes, pick up a color, point to a spot on the illustration, and start! Sometimes starting is the hardest part, but it's the fastest way to finish!

HELPFUL HINTS

There is no right or wrong. All colors work together, so don't be scared to mix it up. The results can be surprising!

Try it. Test your chosen colors on scrap paper before you start coloring your design. You can also test blending techniques and how to use different shapes and patterns for detail work—you can see how different media will blend with or show up on top of your chosen colors. I even use the paper to clean my markers or pens if necessary.

Make a color chart. A color chart is like a test paper for every single color you have! It provides a more accurate way to choose colors than selecting them based on the color of the marker's cap. To make a color chart, color a swatch with each marker, colored pencil, gel pen, etc. Label each swatch with the name or number of the marker so you can easily find it later.

Keep going. Even if you think you've ruined a piece, work through it. I go through the same cycle with my coloring: I love a piece at the beginning, and by the halfway point I nearly always dislike it. Sometimes by the end I love it again, and sometimes I don't, and that's ok. It's important to remember that you're coloring for you—no one else. If you really don't like a piece at the end, stash it away and remember that you learned something. You know what not to do next time. My studio drawers are full of everything from duds to masterpieces!

Be patient. Let markers, gel pens, and paints dry thoroughly between each layer. There's nothing worse than smudging a cluster of freshly inked dots across the page with your hand. Just give them a minute to dry and you can move on to the next layer.

Use caution. Juicy/inky markers can "spit" when you uncap them. Open them away from your art piece.

Work from light to dark. It's much easier to make something darker gradually than to lighten it.

Shade with gray. A mid-tone lavender-gray marker is perfect for adding shadows to your artwork, giving it depth and making it pop right off the page!

Try blending fluid. If you like working with alcohol-based markers, a refillable bottle of blending fluid or a blending pen is a great investment. Aside from enabling you to easily blend colors together, it can help clean up unwanted splatters or mistakes—it may not take some colors away completely, but it will certainly lighten them. I use it to clean the body of my markers as I'm constantly smudging them with inky fingers. When a marker is running out of ink, I find adding a few drops of blending fluid to the ink barrel will make it last a bit longer.

LAYERING AND BLENDING

I love layering and blending colors. It's a great way to create shading and give your finished piece lots of depth and dimension. The trick is to work from the lightest color to the darkest and then go over everything again with the lightest shade to keep the color smooth and bring all the layers together.

1 Apply a base layer with the lightest color.

2 Add the middle color, using it to create shading.

3 Smooth out the color by going over everything with the lightest color.

4 Add the darkest color, giving your shading even more depth. Use the middle color to go over the same area you colored in Step 2.

5 Go over everything with the lightest color as you did in Step 3.

PATTERNING AND DETAILS

Layering and blending will give your coloring depth and dimension. Adding patterning and details will really bring it to life. If you're not convinced, try adding a few details to one of your colored pieces with a white gel pen—that baby will make magic happen! Have fun adding all of the dots, doodles, and swirls you can imagine.

1 Once you've finished your coloring, blending, and layering, go back and add simple patterning like lines or dots. You can add your patterns in black or color. For this leaf, I used two different shades of green pen.

2 Now it's time to add some fun details using paint pens or gel pens. Here, I used white, yellow, and more green.

This design really pops with lots of patterning and little details.

Coloring Supplies

I'm always asked about the mediums I use to color my illustrations. The answer would be really long if I listed every single thing, so here are a few of my favorites. Keep in mind, these are *my* favorites. When you color, you should use YOUR favorites!

Alcohol-based markers. I have many, and a variety of brands. My favorites have a brush nib—it's so versatile. A brush nib is perfect for tiny, tight corners, but also able to cover a large, open space easily. I find I rarely get streaking, and if I do, it's usually because the ink is running low!

Fine-tip pens. Just like with markers, I have lots of different pens. I use them for my layers of detail work and for the itsy bitsy spots my markers can't get into.

Paint pens. These are wonderful! Because the ink is usually opaque, they stand out really well against a dark base color. I use extra fine point pens for their precision. Some paint pens are water based, so I can use a brush to blend the colors and create a cool watercolor effect.

Gel pens. I have a few, but I usually stick to white and neon colors that will stand out on top of dark base colors or other mediums.

Hello Angel #1034, Color by Hello Angel

Hello Angel #1042, Color by Hello Angel

Bloom where you are Planted

Hello Angel #1037, Color by Hello Angel

Hello Angel #1056, Color by Hello Angel

Hello Angel #1048, Color by Hello Angel

Hello Angel #1063, Color by Cathy Pemberton

Hello Angel #1046, Color by Cathy Pemberton

Hello Angel #1059, Color by Darla Tjelmeland

Hello Angel #1055, Color by Hello Angel

Hello Angel #1046, Color by Erica Avedikian

©Hello Angel/Artlicensing.com

©Hello Angel/Artlicensing.com

Be like the flower, turn your face to the sun.

- Kahlil Gibran

It's a beautiful day.
Don't let it get away.

- U2, *Beautiful Day*

©Hello Angel/Artlicensing.com

Oh, tiptoe from the garden
By the garden of the willow tree
And tiptoe through the tulips with me.

- Tiny Tim, *Tiptoe Through the Tulips*

How does your garden grow?

To exist is to change,
to change is to mature,
to mature is to go on
creating oneself endlessly.

- Henri Bergson

©Hello Angel/Artlicensing.com

The main thing is to be moved, to love,
to hope, to tremble, to live.
- AUGUSTE RODIN

Bloom where you are Planted

I'm gonna be the best me.

- MARY J. BLIGE, *DOUBT*

©Hello Angel/Artlicensing.com

You've got every right to a beautiful life.

- SELENA GOMEZ, *WHO SAYS*

©Hello Angel/Artlicensing.com

We live in a rainbow of chaos.

- Paul Cezanne

©Hello Angel/Artlicensing.com

I celebrate myself, and sing myself.

- WALT WHITMAN, *SONG OF MYSELF*

©Hello Angel/Artlicensing.com

> Every flower's reachin' for the sun
>
> – Peter, Paul and Mary, *Every Flower*

When you love and laugh abundantly
you live a beautiful life.
- Unknown

Make each day your masterpiece.

- JOHN WOODEN

©Hello Angel/Artlicensing.com

Don't ask yourself what the world needs;
ask yourself what makes you come alive.
And then go and do that.

- Howard Thurman

©Hello Angel/Artlicensing.com

There are always flowers for those who want to see them.

- Henri Matisse

©Hello Angel/Artlicensing.com

For beautiful eyes, look for the good in others;
for beautiful lips, speak only words of kindness;
and for poise, walk with the knowledge
that you are never alone.

- AUDREY HEPBURN

©Hello Angel/Artlicensing.com

> You have a choice
> Your heart will know
> You gotta look back sometime
> To know where to go
>
> — James Ingram, *Remember the Dream*

Bloom & Grow

Why not go out on a limb?
That's where the fruit is.

- Unknown

Every time you get up
And get back in the race
One more small piece of you
Starts to fall into place.

- Rascal Flatts, *Stand*

©Hello Angel/Artlicensing.com

It is our choices...that show what we truly are,
far more than our abilities.

- J. K. ROWLING, *HARRY POTTER AND THE CHAMBER OF SECRETS*

The best thing to hold onto in life is each other.
- Audrey Hepburn

©Hello Angel/Artlicensing.com

Out of difficulties grow miracles.

- JEAN DE LA BRUYERE

©Hello Angel/Artlicensing.com

Then give to the world
the best that you have,
And the best will come
Back to you.

- MADELINE BRIDGES, *LIFE'S MIRROR*

©Hello Angel/Artlicensing.com

Most of the shadows of this life are caused by standing in one's own sunshine.

- RALPH WALDO EMERSON

©Hello Angel/Artlicensing.com

You are built, not to shrink down to less,
but to blossom into more.

- OPRAH WINFREY

©Hello Angel/Artlicensing.com

The way to know life is to love many things.

- UNKNOWN

Flowers don't tell, they show.

- UNKNOWN

©Hello Angel/Artlicensing.com

I will be the gladdest thing
Under the sun!
I will touch a hundred flowers
And not pick one.

- Edna St. Vincent Millay, *Afternoon on a Hill*

©Hello Angel/Artlicensing.com

Create what sets your heart on fire
and it will illuminate the path ahead.

- KARMA VOCE

Happiness blooms from within.

- UNKNOWN

Do what makes you happy,
be with who makes you smile,
laugh as much as you breathe,
and love as long as you live.

- RACHEL ANN NUNES

There came a time when the risk
to remain tight in the bud was more painful
than the risk it took to blossom.

- ANAÏS NIN

©Hello Angel/Artlicensing.com

Love yourself, even a little bit each day, and your life will bloom into infinite joy.

- AMY LEIGH MERCREE